Diary Inspirations

By Rita Ferdinando

Acknowledgements: *This book was Designed for Inspiration.*

Monday

Tuesday

Wednesday

Thursday

Friday

Saturday

Sunday

Your Notes

Your Notes

Your Notes

Your Notes

Your Notes

Your Notes

Your Notes

Your Notes

Your Notes

Your Notes

Your Notes

Your Notes

Your Notes

Your Notes

⟵――――――――――⟶

Design by Author Rita Ferdinando

www.ingramcontent.com/pod-product-compliance
Lightning Source LLC
Chambersburg PA
CBHW050425180526
45159CB00005B/2412